Vincent & Theo

Brothers in Art

Frank Groothof

Design Stang Gubbels

STICHTING NEDERLANDSE
KINDERJURY
2000

Waanders Publishers, Zwolle
Van Gogh Museum, Amsterdam
Kunsthal Rotterdam

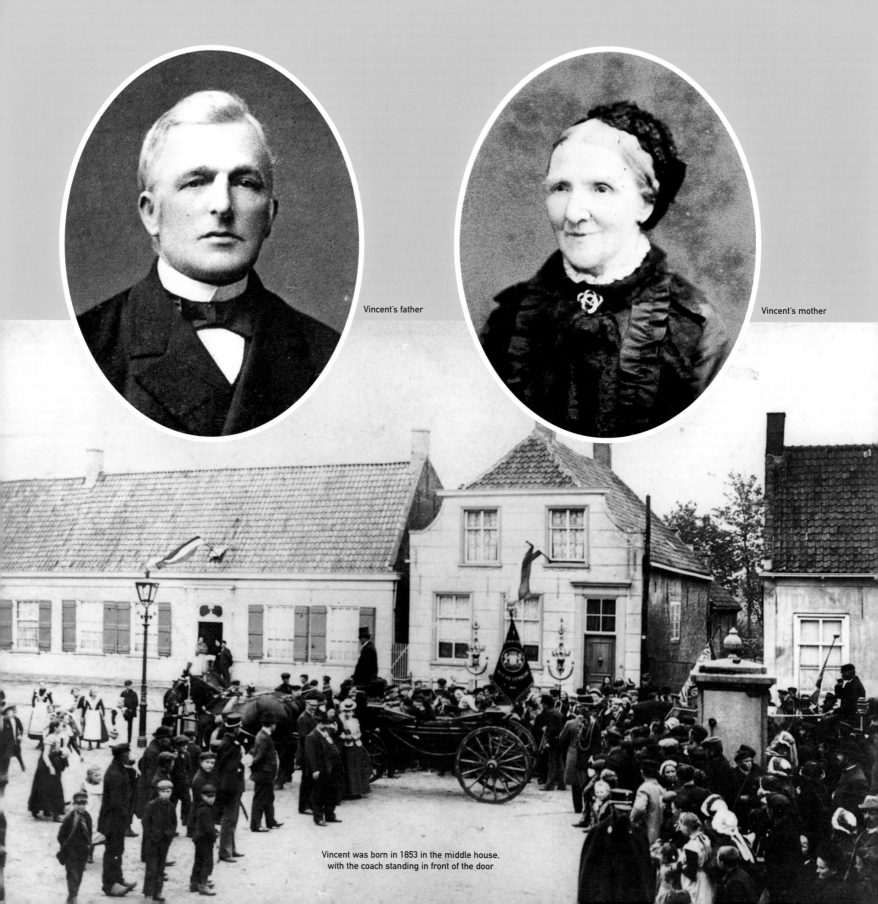

Vincent's father

Vincent's mother

Vincent was born in 1853 in the middle house,
with the coach standing in front of the door

Leaving Zundert

How unfair, how mean, how unkind! I have to leave Zundert. I'm going to boarding school. Far away in Zevenbergen. They think I'm too difficult. "Vincent, it can't go on like this," my father said. "You and your antics." I begged, cried, shouted that I wouldn't go. That I'd pay more attention in future. Mother even had a word with Father. But once Father's made up his mind, it stays made up. Because he's the minister. Because he's ashamed of me. Because our family has to set an example to the village. But I try to be good. I do my best at school.

It's just that stupid Hendrik blamed me for the accident. He bumped into that cupboard himself, so that the whole collection of owl pellets crashed around his ears. But then suddenly it's my fault because I'd been pushing. Is that so strange, with more than eighty children in such a small classroom? I need a bit of space, otherwise I'll suffocate. The teacher gave me such a whack. He always hits first and then asks who was pushing. I kept quiet on purpose. He can say I'm stubborn and unruly but I'm certainly not a sneak. No matter how hard they hit me.

And now Father says I haven't improved since I've been at this school. He thinks I've become "remarkedly rough". That's why they're sending me away. Far away to Zevenbergen. But if I have to go to boarding school, I'll never see Theo again. We'll never again make up adventures at night in our bed in the attic. Happily making plans until deep in the night. With our heads on the same pillow under the sloping roof. Whispering very quietly, because watch out if Father hears that we're not asleep yet. I'll have no one left to play with. No more wandering the moors with Does. And staying away all day. Does hoarse from barking and from running after hares and pheasants. And who'll look after the goats and the donkey? I'll never again go walking with Father and Mother. I'll miss out on everything! The colour of the heather, the speckled starlings on the red roof of Father's church, all the secret, dark places and pathways.

If I cry hard enough, perhaps I won't have to go.

Father and Mother still took me away. In the neighbour's carriage. It rained the whole way. Father kept saying that it's a very good boarding school, expensive too, with a "first class head teacher".

I bit my lip the whole way and didn't say a word. I'm only just eleven, so why do I already have to live somewhere else? Or are they right? Is it perhaps better because I'm really "a strange one" who just makes trouble with his odd behaviour?

But will I be able to live so far from Zundert? How can I be happy without Father and Mother, without Theo and my other brothers and sisters?

I stood and looked for ages, there on the steps of my new school in the rain. At the yellow carriage taking Father and Mother home. I could see them for a long time. On the long road, wet with rain. With the thin trees on either side. The grey arch of the sky reflected in the puddles.

Vincent was very young when he started to make drawings, like this one of a spider in its web

At boarding school

Vincent at the age of 13

It's the worst time of my life at that awful school. I'm the youngest, the smallest and I've also got ginger hair. And I'm new. School began a few days before I arrived so I stuck out even more. The whole troop immediately began to torment me, especially the older boys who call me "carrot top". I try to stay out of their way as much as possible. Yesterday I was standing in the corner of the playground when someone came to tell me I had a visitor.

It was Father! I flung my arms around his neck. I thought he'd come to take me home. Because I'd written that I couldn't stand it here. But Father had come to say I'd have to try even harder. That I should be happy to be at such a good school with children of the "well-to-do" and that I must try to make friends with them.

It's Christmas and I'm home again at last! I'll never forget this Christmas. What a treat! Mother has decorated the tree beautifully. We sang around the tree and tomorrow we'll celebrate the birth of the baby Jesus in Father's church. Theo and I are out a lot. Every day we wander for hours over the snowy moors. I've shown him how to creep up on a partridge's nest without being noticed and lots of other secrets. And we make plans for the future. Everything's fantastic. I can't remember ever having such a good time at home.

Sunday they took me back to school. In order not to worry Father and Mother I acted as if I didn't care. When they left I stared after them from the school window. But then Cor from the second class tried to grab my cap. I just leapt on top of him. Everyone whooping. That old misery from maths saw me fighting. That's why I'll get no dinner tonight. As punishment.

I don't know how I'll get through this time. I don't have any feelings anymore. It's at least seventy days before I can go home again. Until Mother's birthday. And after that I can't go home again until the holidays, and then until Christmas, and then until...

Nearly two more years before I can leave this school for ever. And then I'll already be thirteen!

Secondary school

I made it. And despite everything I even managed to leave boarding school with reasonable grades. Father has big plans for me: "With a sound education you can earn a good living later in an office." So now the holidays are over I have to go to secondary school in Tilburg. I can forget about roaming the moors for the time being. Sent away again, living with strangers again. I get stomach cramps just thinking about it.

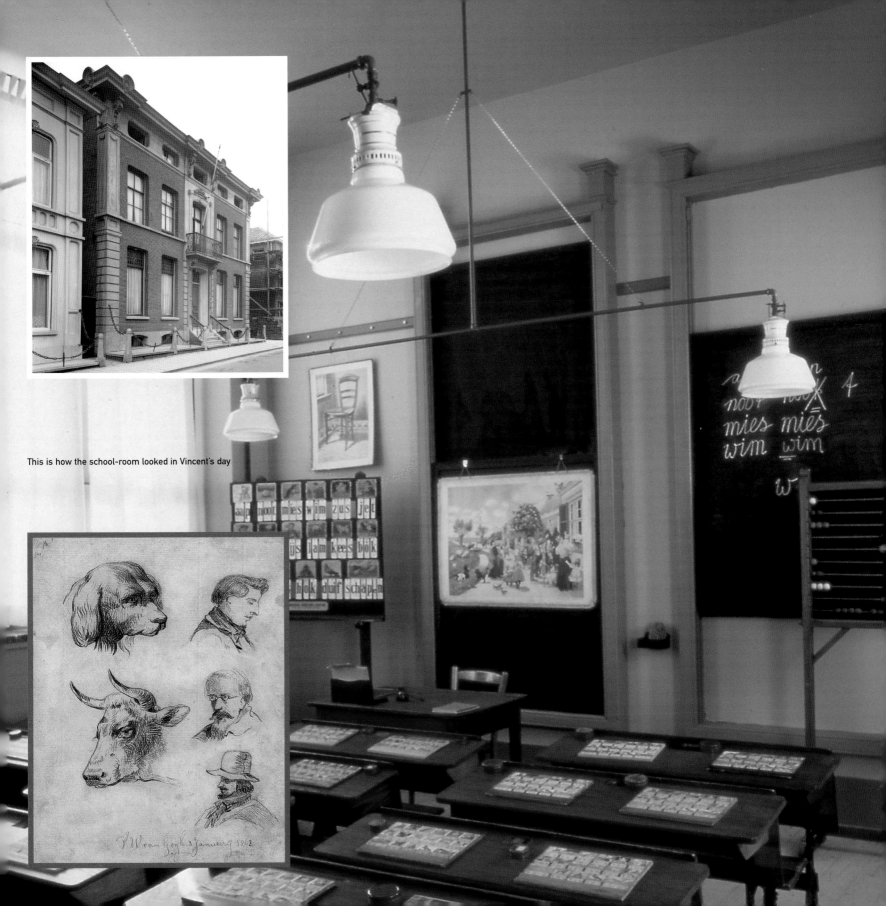

This is how the school-room looked in Vincent's day

Father has put an advertisement in the newspaper. "Board and lodging for a young gentleman."

So now I live with the family Hannink in Tilburg. They have a son at the same school, but he's five years older than me. It's swotting from early morning to late at night. I find maths particularly difficult.

We also have drawing lessons, four hours a week. Just for a moment, I thought drawing was nice. But it's a disappointment because we're only allowed to copy pictures and stuffed animals. Thinking up your own subject is not allowed. This is the upteenth lesson I don't think much of.

I still get stomach cramps. But I've found a way of getting through all those lessons. I just daydream about Zundert. About climbing up to the magpie nest in the tall acacia tree in the churchyard. Or about wandering through the fields and over the moors.

The trouble is that when the teacher asks me something, I have no idea what it's about. But, of course, it's also because I often can't sleep at night.

Recently I just burst into tears in class. I don't know why. I was so ashamed. And another time everything suddenly went black before my eyes, as if I was about to faint. My grades are getting worse and worse. I can only think about home.

Yesterday I finally did it. Instead of going to school, I walked home. Thirty kilometres, with long stretches straight through fields and woods. I could breathe again! It was already dark when I finally reached home. They

were shocked when I suddenly appeared in front of them. Father was furious! He told me I was a wimp, that it was the best school he could afford, that the school fees were now a waste of money, that I was a fine example for the rest of the village. He went on and on.

Mother was mainly shocked because I looked so ill.

I just stay in bed. Why should I get up? I can't go anywhere.

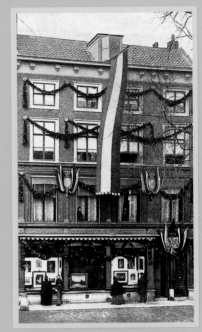

Goupil's art gallery where Vincent worked for a while

Everyone thinks I'm a complete failure. Even Theo says so.

Vincent gets a job

Father thinks any more education is useless. He's arranged a job for me through my uncle who's an art dealer. I'm going to work in an art gallery in The Hague where they sell paintings and reproductions. But what do I know about paintings? They're bound to sack me before long. But there are some beautiful things. Recently a painter brought in a new canvas. I listened to this man for hours as he talked about his work. After that I went to Amsterdam, because he said there was an exhibition there about Dutch painters. It was marvellous. Father is pleased that I've finally found something I like.

Theo van Gogh

Theo, too, seems to be doing worse and worse at school, so Father has arranged a similiar job for him. With an art dealer in Brussels. I'll take my little brother under my wing and encourage an interest in painting. I'm going to write immediately: "Dear Theo, now we are brothers in art."

London

It's going very well! They're so pleased with me at work that they even asked if I'd work for a while in London. Probably to get some experience of English painting.
At first, I really didn't want to leave The Hague. But in the end I did, and now I think it's fantastic here. I'm renting rooms from a woman with a really sweet daughter. She's called Eugenie. Eugenie. Doesn't that sound like the rustle of a spring breeze through the reeds! I immediately bought one of those very English top hats and I walk to work every day now wearing it. Then I can think quietly about how I should approach Eugenie. Because I want to marry her. It's just that I haven't yet dared to tell her that I love her. That's because I've already been turned down once in The Hague by a girl I was crazy about. But I acted too quickly. So now I want to be more sure of my case first. Maybe I'll tell her at Christmas. Yes, on Christmas Eve I'll ask her to marry me.

She said she already has someone else. Someone who rented the rooms before me. I said: "Finish with him then!" But she doesn't want to. I can't live here any longer. I want to leave, to go home, back to Zundert. It's better if I never see her again. Oh my dearest Eugenie.
At work they're cross with me because I want to return to Holland, but I don't care. I'll be glad when I can leave this foggy horrid city. And anyway selling paintings is definitely not for me. Always tidy in a suit and bowing like a jackknife for everyone and saying yes and amen.
No, I'm going to do something else. But what? Everything I try always goes wrong. I wish everything didn't look so hopeless.

Vincent becomes an artist

Theo is now working for an art dealer in Paris. At last things are going well for him. He's turning into a real little gentleman! He writes that perhaps I should become an artist. That I should start painting myself. Well, well. My younger brother is telling me what to do! I thought: "Oh man, you're talking through your hat. I can't even draw." But he wrote that I just had to practice, because then later he could sell my paintings in his gallery. So I just began to draw. Just something in the garden or a farmer here in the neighbourhood working on the land.

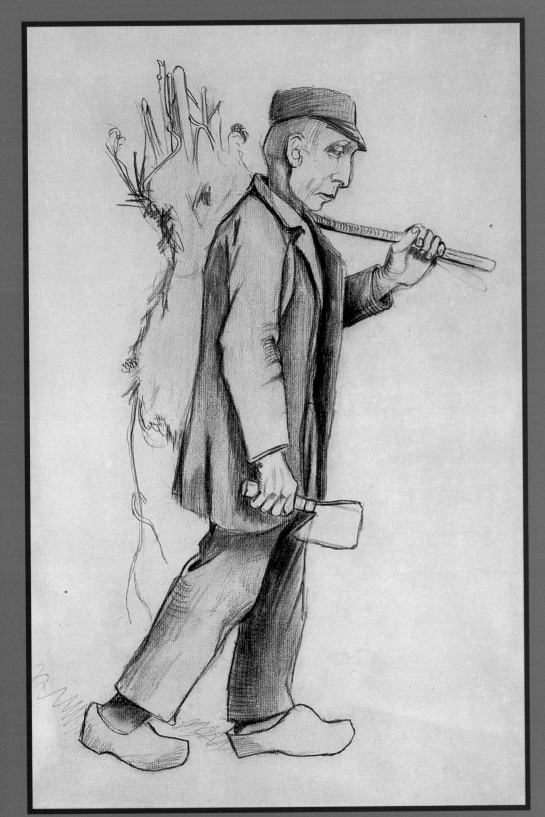

Vincent drew this farmer shortly after he decided to become an artist

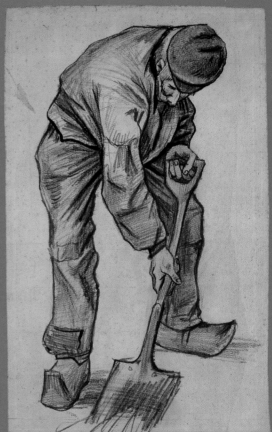

The digger

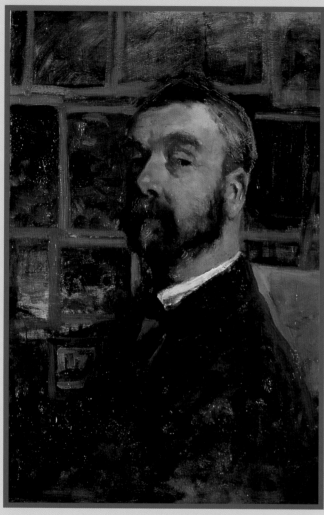

The painter Anton Mauve, Vincent's cousin

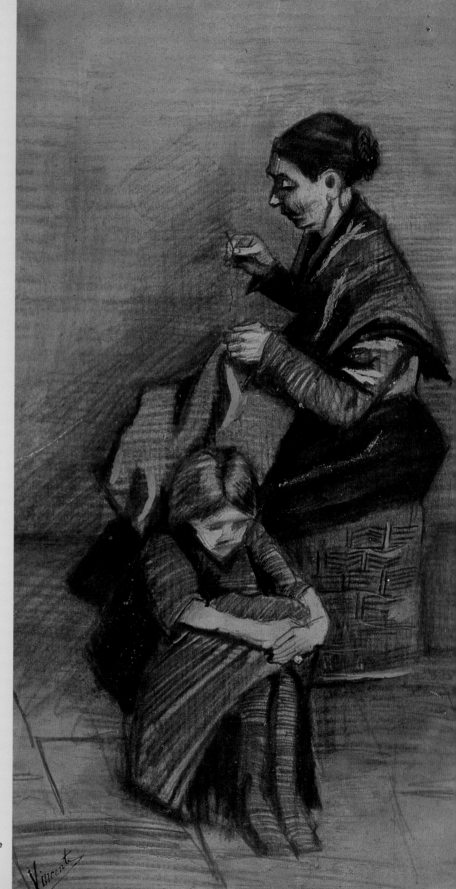

Sien, the woman who lived with Vincent in The Hague

Or I draw copies of pictures of famous paintings. The only thing is that I'd like to meet a real painter one day, so he could teach me how to get more depth into my drawings.

Those drawing lessons at school were really useless. I learnt absolutely nothing from them.

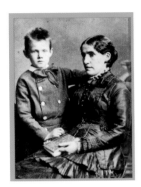
Kee Vos with her son

My cousin Kee Vos and her two year old son have come to live with us. Kee is still mourning her husband who died a few years ago. I think she's so beautiful, especially when she cries. I thought: this time I'll do things completely differently. Perhaps she'll marry me when she sees how nice I am to her little boy. So I played with the little one. We also took lots of long walks. Then we could talk endlessly about anything and everything. I kept thinking how wonderful it would be to take care of Kee and her child. When Father and Mother went for a stroll one morning, I summoned all my courage and proposed to her. And what do you think? She immediately packed all her things and left at once. I must have written her ten letters but she never replied. Now I'm here alone with Father and Mother again. It's hopeless. I might as well give up. I'll never find a wife.

And Father has been nagging lately that I should do something with my life. That if necessary I should become a baker. Where does he get these ideas from! I was furious. I absolutely can't stand it here at home any longer.

Back to The Hague

Theo has come from Paris. He has lent me some money for the time being, so that I can rent a small room in The Hague. Now at least I'm away from the nagging. I live near my cousin Anton Mauve who's a well-known painter. We've agreed that I will take painting lessons from him. And Theo has promised that he'll send me some money every month to buy food and paint until my paintings are good enough to be sold.

I've already had a few lessons from Mauve. First I had to do a still life for him. "A still life is the beginning of everything. If you can paint a still life, you can also paint a wood" He threw a pair of dead pheasants on the table which I had to paint. But I think this sort of subject is just showing off. I'm interested in real country life. I thought: I'll just start with a potato. The wood can wait until later. I laid the food for my evening meal on the table, cabbage with potatoes. I put my clogs next to them for some atmosphere. And that's what I painted. I don't think he thought much of it. But I'm learning a great deal from him. If only I didn't feel so terribly alone all the time.

Dear Theo, listen to this! I met a woman in a cafe who will pose for me. She's called Sien and when I painted her, she told me that she lives with her child in the poorhouse. I immediately said: come and live with me! It's so cosy here now! And you know what's so handy? I always have a free model now! Mind you, the neighbours don't seem to approve because lately they don't want to talk to me any more. And I'm suddenly no longer welcome at Mauve's because of Sien.

This is where Vincent lived with his parents in Nuenen

But I don't care. He can get lost with his stinking pheasants. I'm the one who'll decide who lives with me.

It's so awful to always have money troubles. And with these extra mouths, it's really difficult with money lately. That's why I try to get credit every now and then. The other day I finally managed to get a loaf of bread again. I come home, proud as a peacock that I have something for them to eat, and I go into such a skid! Sien's little monster has made a complete mess of the floor with my expensive paint! Oh well, of course she must allowed to play, but now I can't paint any more! Just as I was about to teach her a thing or two, the door opened. Theo! I slithered through the paint towards him. I thought: just act as if nothing's happened. Usually, Theo is the one person who understands me, but now he said:

"Vincent, this can't go on like this any longer. This mess and debts everywhere and paint daubs. If you don't send that woman and her child away, then you won't get another cent from me."

"Keep your money then," I shouted. "I can't abandon this poor woman to her fate, can I?"

"Oh man, don't you understand that she's using you. She's a whore. She's no good."

I pushed him out of the room and slammed the door in his face. "Keep your rotten money because I'll never give up Sien!"

But now Sien herself left with her child. She thought I spent too much money on paint so that not enough was left for her.

I'll never find a woman who'll want to live with me. Never, never! It would be better if I put it right out of my head.

Vincent moves to Nuenen

I went back to live with my parents again. In the meantime they had moved to Nuenen where my father had another job as minister. There was nothing left for me in The Hague. Sien was gone and Mauve didn't want to know me any more, so what could I do?

I don't think my parents were very happy when I appeared under their nose. But they didn't send me away either. Mother thought I was like a big shaggy dog. She was obviously afraid I would shed hairs all over the couch because she wanted to get me into Father's old suits. But I'm not going to walk around in these monkey suits. I'm not a minister. I'm an artist!

The worst thing for Father is that I don't go to church any more. They think I've become a sinner. Well, as long as they leave me in peace. I want to paint again! So I wrote to Theo that I'm allowed to use Mother's drying room as a studio and that we can get on with our plan. Thank goodness he's now sending me some money again every month so that I

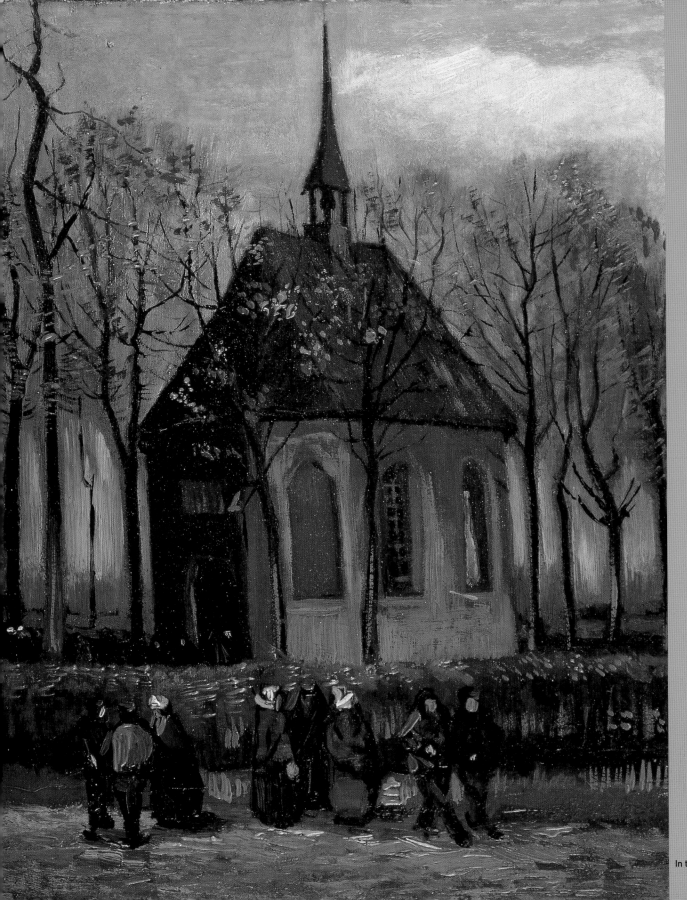

In this church Vincent's father preached

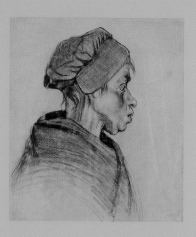
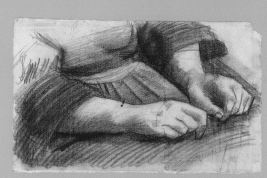
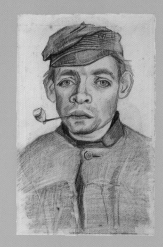

Three drawings by Vincent

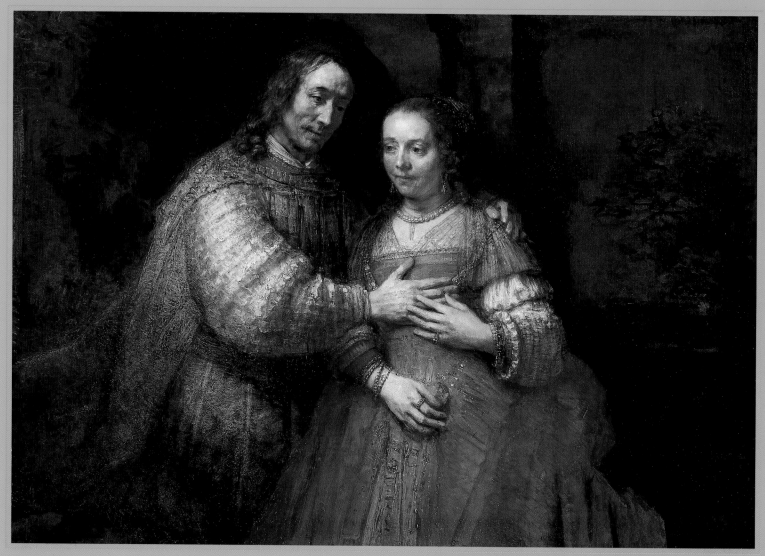

The Jewish Bride by Rembrandt van Rijn

can buy paint. I draw from early morning until late at night: the weavers at their looms, the women planting potatoes, the farmers with their callused fists, the heads of the farmers' wives. When I see these poor women with a child in their arms or at their breast, it's as if I see my own Sien again with her thin little body. I don't know how long I can bear this loneliness.

As soon as I've finished a few paintings, I send them to Theo so that he can sell them in his gallery. The trouble is he's never sold one yet. Sometimes he doesn't even respond to my paintings. Or he writes that first they will have to improve, and lighten in colour. But so far he's never had a good word to say about my work. Of course, it's far from good enough, but on the other hand I don't think he even makes an effort to sell them.

A weaver at his loom

If only I wasn't so dependent on him! He can't sell my work and he won't allow me to have a wife and child. Yes, I can have money from him, but what good is money if I can't have those other things! I don't want to keep taking handouts. I'll write him a letter. I'll just write something like: "Dear Theo, thanks for the money that you're still sending. But from now on I'll think of your money not as a gift but as payment for the paintings I keep sending you."

Theo didn't even react to my suggestion. He wrote: "Vincent, paint a bit lighter for once, a bit more cheerfully and brighter." But how can I do that when my life is so cheerless and miserable?
Sometimes a so-called art lover from around here goes on at me about how he likes this or that painting. But that just tells me it's no good and I quickly paint over it.
Luckily, I do get on with a man who lives not far from here. His name is Kerssemakers and he tries to paint, too. I help him occasionally and sometimes we go out together. Once I asked him what he actually thought about my paintings. "Ah, well now, er, um... I don't know... um," he said. "I think I find them rather... ah... a bit crude perhaps and er... not yet entirely well finished."

"Just wait," I said, "you'll think differently about them later on." That afternoon, when we were on our way to the Rijksmuseum in Amsterdam, he suddenly said: "You know Vincent, they have made an impression on me because I can still see your paintings in my mind's eye." Impression! He clearly wanted to make amends.
But talking about impression! In the Rijksmuseum I saw
a painting by Rembrandt. The Jewish Bride. God, how beautiful. My eyes filled with tears! I would give years of my life just to be allowed to look at that painting for fourteen days. With just a dry crust of bread to eat. Rembrandt is a perfect painter. When, for instance, he painted those members of the Draper's Guild it had to be a perfect likeness. But when he wasn't painting a portrait, when it didn't have to be such a perfect likeness and he could do his own thing, Rembrandt could also do something else. He could catch the emotions of a person in his painting, like a poet does in words. Yes, that's what he did in The Jewish Bride: painted a poem.

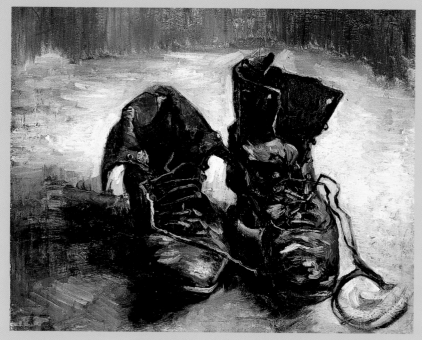

This is how Vincent painted his shoes

Dear Theo, thanks for your letter. I'm glad you're doing so well in Paris. It's wonderful that the gentlemen there have so much faith in you that they leave the running of the gallery more and more in your hands.

Life is so boring here. I have no real contact with anyone in this village. That's why I'm also so pleased with that art book you recently sent me. At least I have something to read of an evening.

By the way, I'm going to send you another new painting. The Potato Eaters. It's a real rural painting in the colours of a nice muddy potato, unpeeled of course. It seemed to me a challenge to paint four people at table. But afterwards I thought the painting was rather empty. That's why I added a woman on the right-hand side. Because she couldn't reach the bowl of potatoes, I've painted her pouring the coffee. (Although no one here drinks coffee with the evening meal.) I'll be interested to know what you think of it. Probably that

it's too gloomy in colour again. But life just is gloomy. Instead of lighter, I think my paintings should be even darker.

Theo wrote to say that he did indeed find The Potato Eaters too dark. That because of this he can't sell it. But that there's a new style of painting in Paris, much lighter in colour. It's called Impressionism. I'm not all that interested. I already find The Jewish Bride so overwhelming that I'm not really curious about anything new.

But Theo says Paris is where it's all happening and that's why I must come to Paris this summer. I'm amazed: go and live with Theo, finally leave this hole! Suddenly I'm so keen to travel that I paint my old, battered shoes in excitement, because I can't take them to Paris with me. I can hardly arrive at Theo's looking like a tramp. Goodbye shoes which have seen me through so many endless trips. Goodbye yellow room. Vincent is leaving you behind because he's off to Paris!

With Theo in Paris

Theo wrote that I can't come until the summer because then he can get a bigger place to live. But I still went immediately. I thought it would be better not to appear in that expensive gallery in my old clothes. So I wrote him a quick letter: Dear Theo, sorry I'm already here but I couldn't wait any longer. So come as quickly as you can. I'm waiting in the large room at the Louvre.

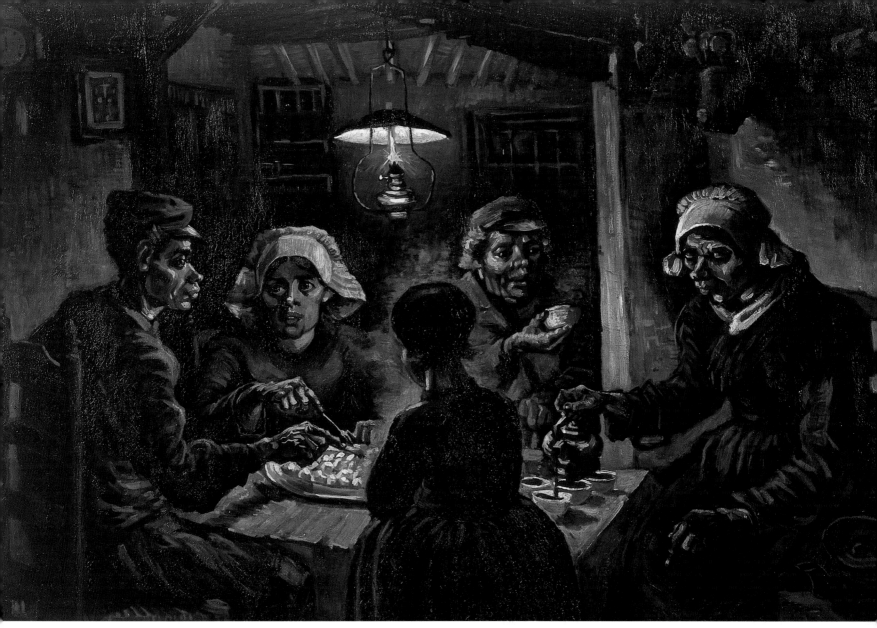

The Potato Eaters, **painted in 1885**

Sketch for *The Potato Eaters* The first letter Vincent wrote to Theo in Paris Sketch for *The Potato Eaters*

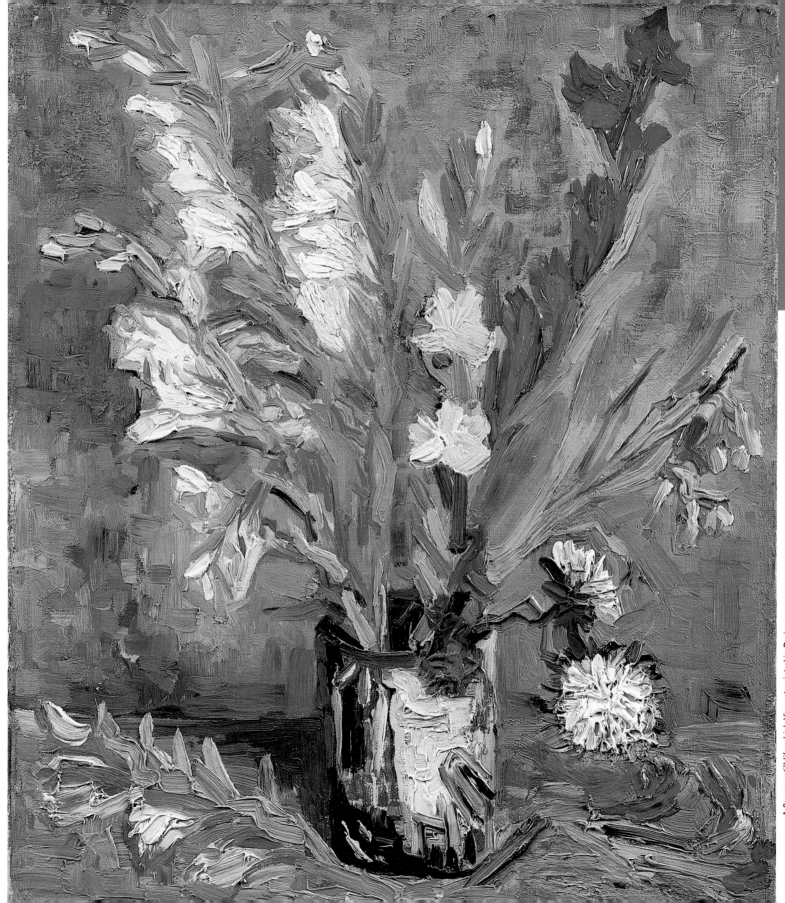

A flowers still life which Vincent painted in Paris

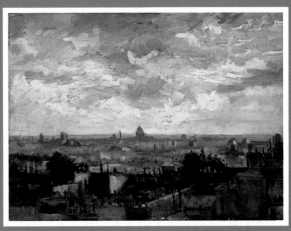

Painting by Henri de Toulouse-Lautrec

Painting by Georges Seurat

Painting by Vincent van Gogh

I found a boy to take the letter to Theo and used the time
to draw some of the museum visitors while I waited.
It was so good to see Theo again. He's my best friend.
Why didn't I come to him before? Theo was also very
pleased, but I think I came at an inconvenient time because
he was huffing away. "Where am I going to put all this
painting stuff of yours in my small apartment?"
Luckily he's now arranged for me to work in the painter
Fern and Cormon's studio. There are other young artists
there, all of them working in the new impressionistic style.
I haven't started on styles yet. I want to learn to paint in
strong colours. That's why I do flower still lifes in all the
colours of the rainbow. Working with many colours is so
different to what I've done so far that I already have my
hands full.
Sometimes I hear the other boys laughing behind my back.
They call me "the garden gnome" because of all my flowers
and my red beard. But I don't take any notice! I'll keep
painting flower still lifes just as long as it takes to learn
how to combine the profusion of colours.

Theo thinks my work already bears no comparison to
those gloomy paintings I did in Holland and that I'm
making rapid progress. All the same, he still hasn't sold
anything. That's why I sometimes swap my paintings with
other painters. This way I'll eventually have a good
collection which will also be worth money, of course.
Sometimes I'm visited by other painters like Gauguin,
Toulouse-Lautrec and Seurat. They have also invited me
to take a look around their studio. Some of them paint in
a very peculiar way, with all sorts of dots and spots and
often just primary colours. It's a real eye-opener. I want to
try it too! I think it will make the colours in my paintings
even more powerful and brighter.

Hurrah! Theo has moved to a larger apartment. Now I
finally have my own studio! Just in time, because it was
beginning to get on my nerves at Cormon's. It's far too
noisy there to be able to paint quietly.
I thought it was because of this commotion that I felt so
wretched. My stomach has been playing up a lot recently!

But Theo went to the doctor with me and it seems that it's to do with my teeth. Just about all of them were rotten. So the dentist has now pulled all my teeth. And it really helped. I feel much better! Goodbye French bread. Long live bread pudding and medical science!

From the window in my new room I'm now painting the view over the roofs of Paris. Without stomach ache at last.

Now that I feel better, I often work outside. Preferably in Montmartre, a district on the edge of the city. It's wonderfully rural there with all those picturesque windmills and crooked old houses. Half Paris goes there on Sundays to escape the bustle of the city. So I often wander even further and in this way I explore the vicinity of Paris. Then I paint landscapes in the style of my friends, with all those dots. But I also try it with tiny dashes and smudges because the effect then is even more powerful. It's fun to experiment with all these techniques and I'm gradually getting better at making my palet lighter and more colourful.

I found a pile of splendid Japanese pen-and-ink drawings in a junk shop which, would you believe, the owner was using to wrap up his things!

Theo and I now collect Japanese prints because we're crazy about the way in which they are painted. Fast, very fast, with one single pen stroke like a flash of lightning

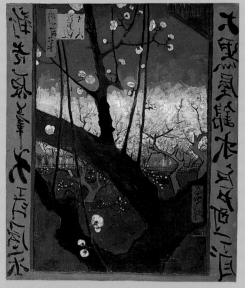

Vincent copied Japanese prints in Paris, like this flowering tree

which conjures up a whole world. And then those almost even, large areas of strong colours. I used one of these prints as an example and then painted a flowering plum tree in the way they do it. Then a brightly coloured frame around it with those beautiful Japanese characters on it. No idea what it means, but according to Theo it looks very fashionable.

I also read everything about Japanese artists. Sometimes they live in an artists' colony together. I think that would be fantastic; to begin an artists' workplace like this with other painters. And then live like monks just for art's sake.

Sometimes Theo can be moody. He suddenly thinks the house is a pigsty because painting things are lying around. I don't understand why he makes such a fuss. I might just as well make a fuss because, for instance, he's never yet sold anything of mine. Or because, in any case, hardly any modern paintings hang in his gallery. No, the same old rubbish still hangs there, just as it did years ago when I escaped from that art dealer's shop. The same feeble paintings from the time when everyone wore wigs! But there's hardly any of the art of today which my friends and I are busy with. How can we ever sell anything if the galleries won't show our paintings! Then, of course, people think it's not real art. So they never take our work seriously and they can't get used to our new style either.

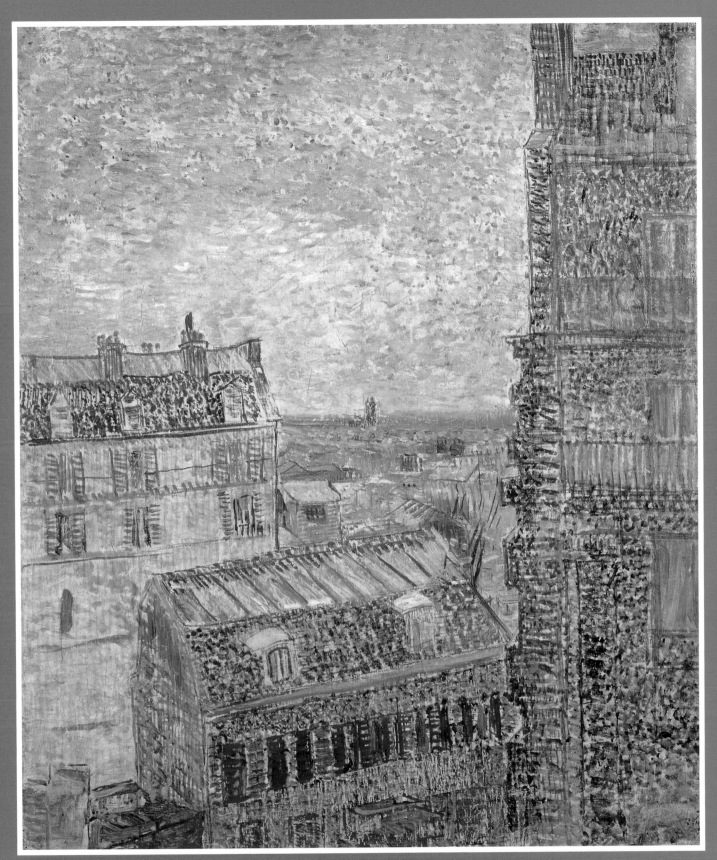

A view over the roofs of Paris, painted by Vincent

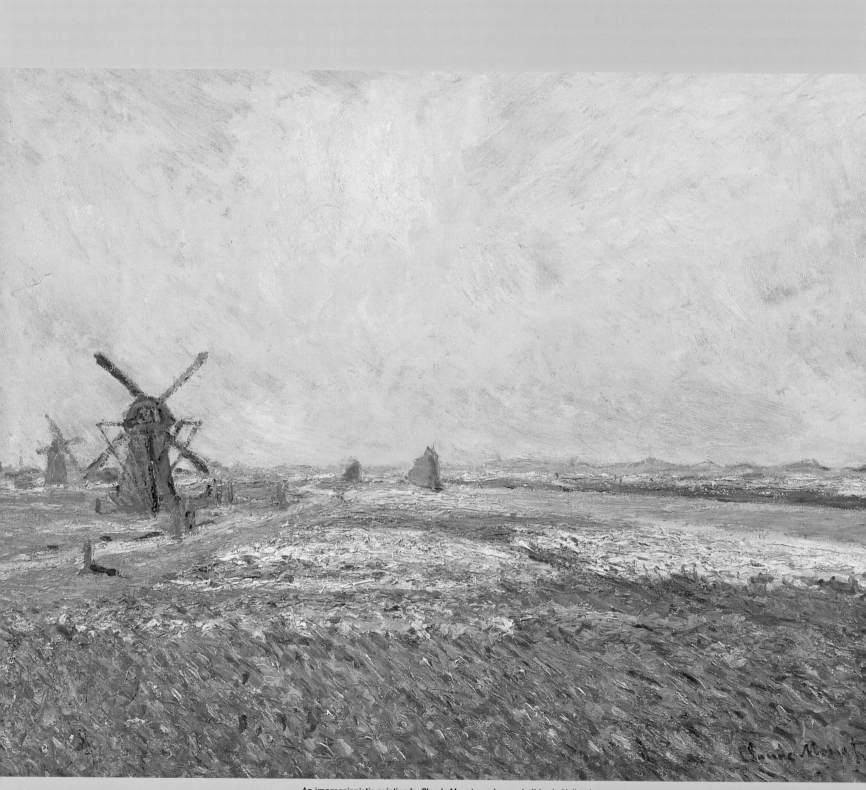

An impressionistic painting by Claude Monet, made on a holiday in Holland

Theo said: "Vincent, it was me who introduced you to those fellows. You must know that I think their paintings are marvellous. But my boss doesn't like them. He thinks the colours are ugly, that they're sloppily painted. In short: definitely not art!"

I said: "Well if you think they're so marvellous, why don't you start your own shop for Impressionist art?"

"Oh man, how can I afford that. I'm not made of money! And anyway one of Monet's paintings has been hanging in the shop for ages, so I'm really doing my best. But people just don't want it!"

"Yes, don't I know it. You can't just hang one painting. You have to fill the whole shop. We must pave the streets with them! Impressionism in the bathroom! Pointillism in the privy! People must be able to see nothing but modern art. Only then will it sell! But if you're too lazy for all this, then I'll organise an exhibition myself with work by me and my friends."

Well, daggers were drawn. Theo was furious. He dragged up everything. The mess I make at home. That he can no longer bring his friends home because, according to Sir, I go on a bit too much about art. And the upshot was that he stormed off. I don't know what's the matter with him these days!

Thank goodness! Theo and I have made up. And he's finally managed it. His boss has agreed that he can hang modern paintings in part of the gallery! Now we're going to make sure that his shop is the centre for Impressionist painting. I ask all the young painters, Gauguin, Monet, Sisley, Pissarro, Raffaèlli, Degas, Seurat, Bernard, all my friends

to exhibit there. And then we invite the public to come and have a look. Then we can at least explain to them why we paint in this way.

There are so many things here which I'd love to paint. But for one reason or another I don't manage it. Models won't pose for me.

I'm not allowed to paint in the street any more because they say I create a disturbance. That's why I'm painting myself again. Actually it's only because of this that I see how exhausted I look. As if I'm becoming ill. Perhaps it's all to do with this rotten cold. And because I work too hard. Because of this I drink in order to keep going a bit longer. And in this

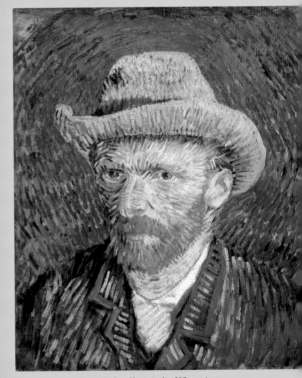

A self-portrait of Vincent

way I'm gradually wearing myself out.

My friend Toulouse-Lautrec thinks all's not well with me, too. "Why don't you go to the South of France for a while?" he said. "You'll find the Mediterranean Sea there with its ever-changing tints. Sometimes it's the colour of a mackerel, green or violet; the next second it's azure blue. And then Marseille with all those cheerful coloured houses!

Vincent in Arles

The climate there is so wonderful that you'll get better automatically."

He's right. I have to leave here as quickly as possible.

So I said: "Theo, I'm off to the south. I can't stand it here any longer."

"To the south? But what about me? These new ideas of yours are finally catching on. More and more people are coming to the shop to look at your paintings."

"Theo, if I don't go, I'll be even more ill. I'm going crazy here in Paris."

"But it's just going so well. It will suddenly seem very empty to me. Because although I sometimes find you impossible to live with Vincent, I've become very attached to you!"

"I'll fill my studio with paintings and drawings. Then it will seem as if I'm still here and you won't miss me so much. And of course I'll write to you as often as possible to tell you about everything."

After a lot of pleading, Theo finally took me to the train.

Dear Theo, during my journey I thought just as much about you as about this new world I can see. You know, the Provence, which makes you think: it's further south so nice and warm. And yet there's a thick covering of snow here and it's really cold!

But also beautiful, with the mountains with their white tops standing out against the blue sky. Just like one of those prints of a Japanese winter landscape.

You wrote that you might get engaged to Jo Bonger, that girl from Amsterdam. What great news. Congratulations! See how much more practical it is that I came here. When you are on your honeymoon, you must also come to Arles. I know a small hotel here for you. I've taken a room there myself. It's near the station and full of atmosphere. I went outside this morning to paint but it was freezing cold! Sometimes in the afternoons, too, I'm surprised by a snow shower. Fortunately, an old woman called me indoors to shelter. She actually wanted to pose, so I painted her.

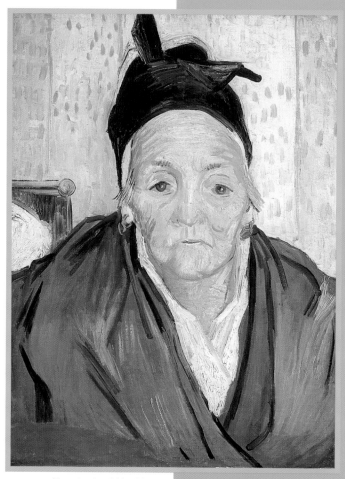

Vincent painted this old woman soon after he arrived in Arles

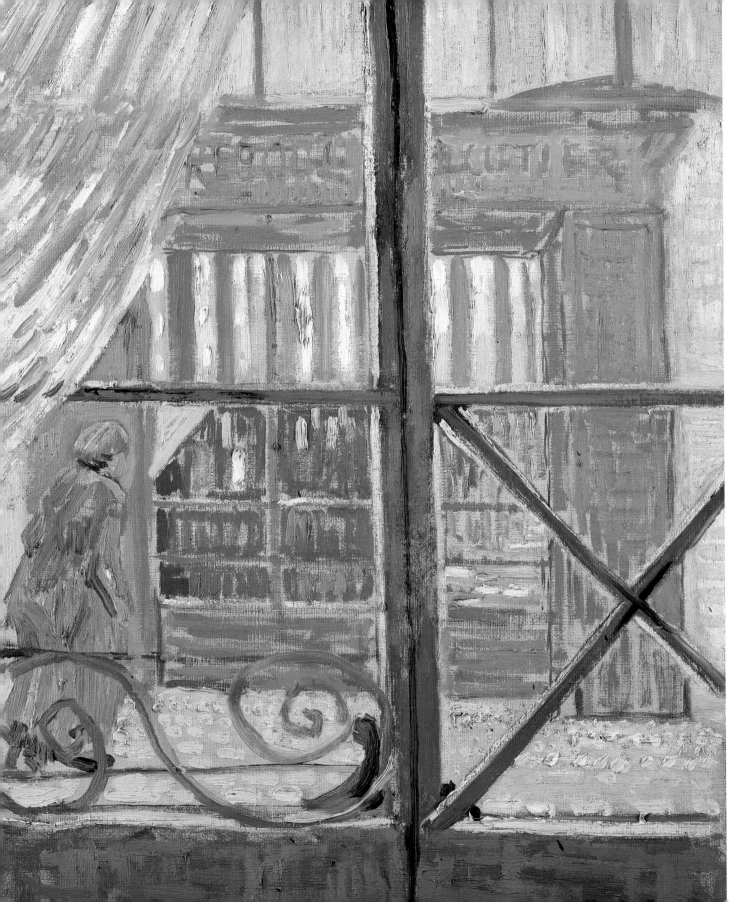

The view from Vincent's hotel room

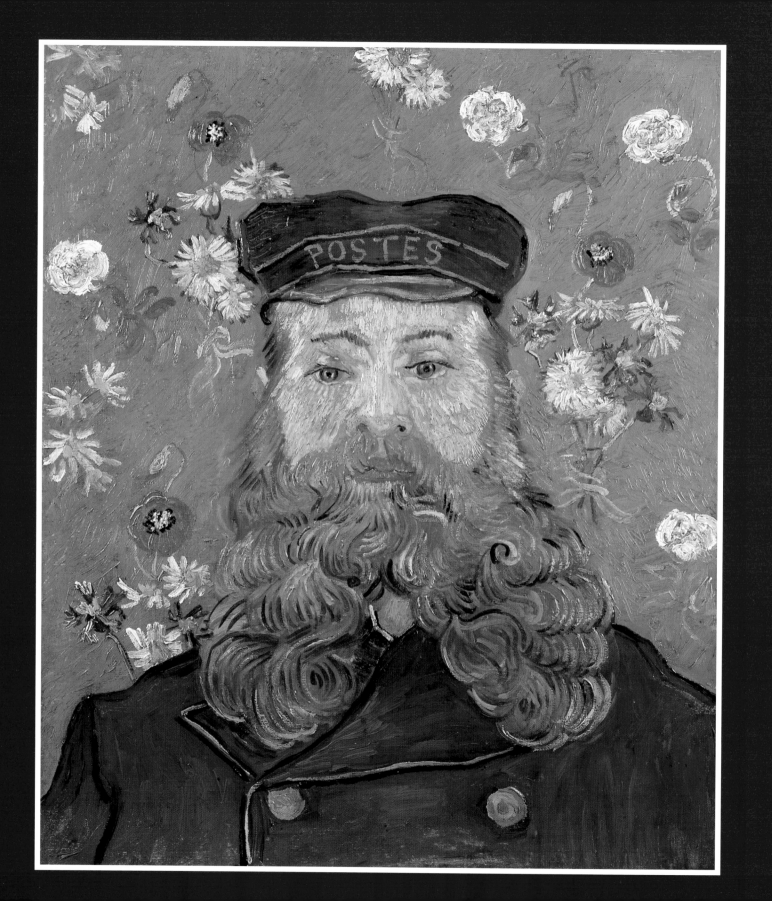

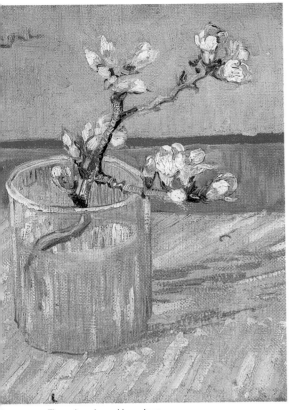
Flowering almond in a glass

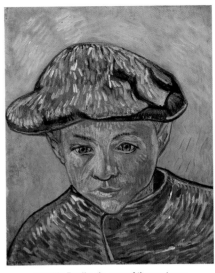
Camille Roulin, the son of the postman

What a nuisance. It's still freezing and there's thick snow everywhere. I can't go out because my fingers will freeze off. But I want to work! That's why I settled for painting the view from my hotel window. And also a flowering almond branch and all sorts of other still lifes. But it doesn't amount to much. It will have to get much warmer before I will be able to work comfortably!

Theo, the weather is finally getting a bit better. I immediately went outside and guess what? I found a drawbridge just like we have in Holland! Of course I painted it, with a small carriage on it and a group of washer women in front. It was just like a flock of twittering thrushes when they noticed they were being painted. I enclose a sketch of it. Does that look like a Dutch bridge or not?
All the orchards here are in bloom. It's an unbelievable sight. I had begun to paint a group of apricot trees, but these flowering orchards are so beautiful now, I want to paint them all: peaches, plums, apples, pears... I could go on. They're just too beautiful. I work like a madman every day with thick layers of paint and rough strokes. I get up at five o'clock and work until it's too dark to see properly. It's been so windy recently that I have to peg down my easel. And yet I keep going, because I want them all done before they finish flowering.

Dear Theo, I already have a friend here! He's called Joseph and he's the postman in Arles. He's a nice chap and I drink a glass of wine with him now and then. When he brought the post, he shone like a sunflower. He said that his wife had just given birth to a baby girl. I'd already asked him if he'd pose for me sometime and now he just sat down ready on the terrace of my hotel. I painted him in one go, in his dark blue uniform. In one go! That means I'm beginning to get the hang of portrait painting. If I can persuade him to let me paint his child, too, then one of these days I'll also paint a baby in a cot.
It's just that the woman from the hotel complained again that there was paint on her tables. I'm beginning to like it here less and less. They're not nice any more and the food is awful. And when I need to eat well and healthily to regain my strength, too. That's why I looked for another place to stay and I've now found a small house with four rooms!

Joseph Roulin, Vincent's friend the postman

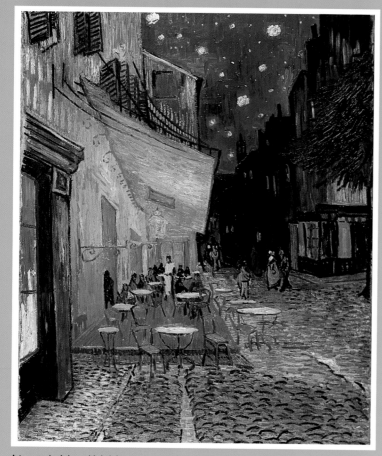

A terrace in Arles with bright stars

you can see how cosy it is here. It's just a shame that I haven't been able to work outside much lately. That's because I don't feel well again. It's my stomach. I'm rather fed-up because if I'd felt better I would have done some quick landscapes.

Theo, when I had just arrived here I hoped I'd meet other artists. But apart from Joseph and his wife, I haven't made any progress with these people at all. Days go by when I don't say a word to anyone, except to order coffee or food. I think they find me a strange fellow here. The grocer's wife makes that quite clear. She won't even allow me in her shop any more. She calls me a scarecrow and says I smell. She wraps my money in a piece of paper, pulls a face and puts it down well out of the way. I certainly told her a thing or two. But now it seems that suddenly everyone here hates me.

It's on the corner of the square and the outside is painted completely yellow. I've rented it for just fifteen francs a month. I can already work there but I can't move in yet because I have no furniture and no bed. I've painted the house for you so you can see how beautiful it is. My friend the postman lives at the end of the street, to the left of the railway bridge.

Dear Theo, thanks for the hundred francs you sent me. I've been up early every day and worked right through so that I now have three paintings finished. Three paintings of sunflowers. And I also did a painting of my bedroom. So now

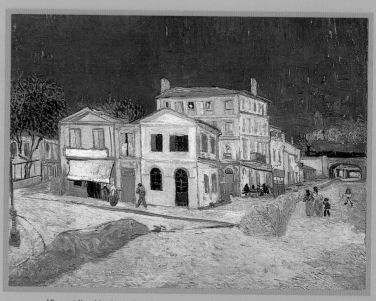

Vincent lived in the yellow house on the corner, with the green shutters

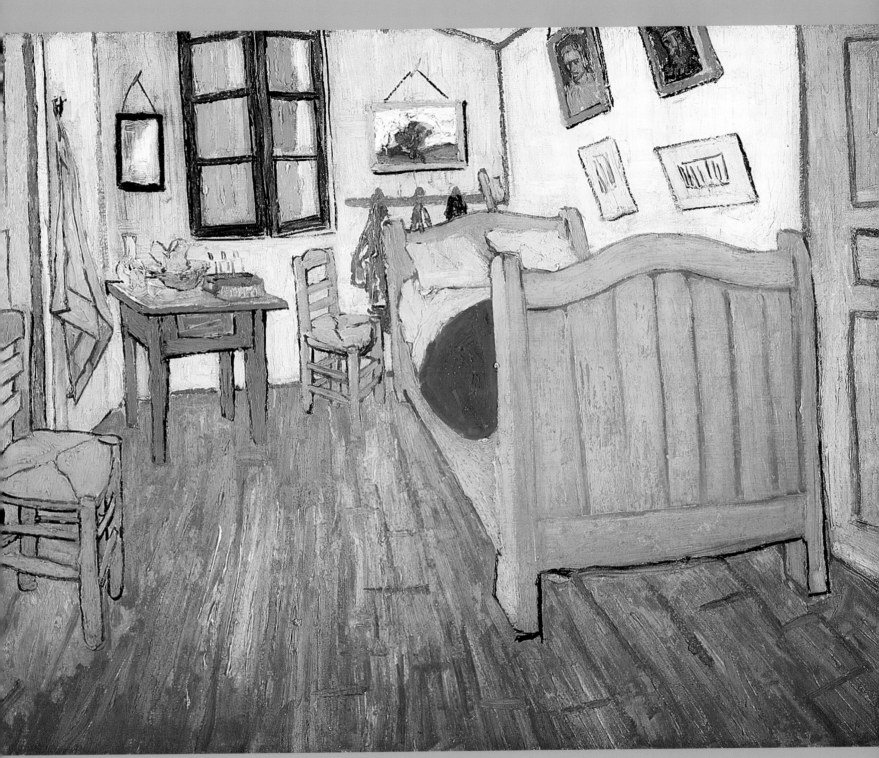

Vincent's bedroom in the yellow house

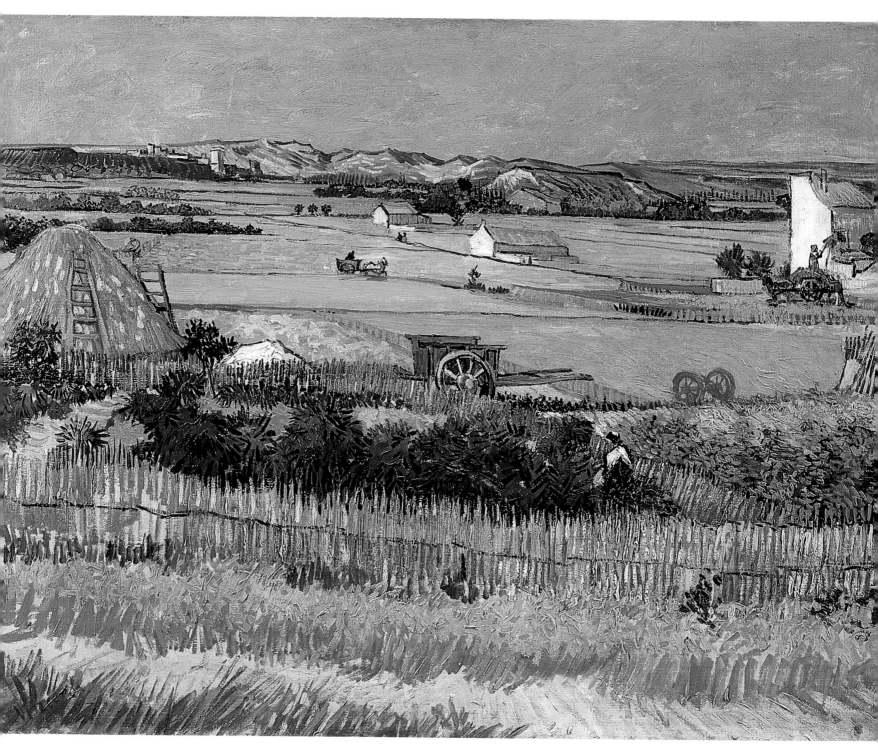

People worked hard in the fields around Arles. Here they are harvesting

Well, I don't care. After all, I'm not often home at the moment. I'm painting the area of La Crau where they're now harvesting. But Joseph just came here to tell me he's being transferred to Marseille. There goes the only friend I have here!

Dear Theo, I just got a letter from Gauguin. He writes that he is in Bretagne. He went there to paint. But he's completely broke and can't pay for his lodging any more. And would I ask you to hang one of his paintings in your shop. If it sells, he can at least pay off his debts and return to Paris.
Of course I hope you do this, but I just had a wonderful idea. I shall ask Gauguin if he'll come to Arles. The house is big enough for two. Of course, we'll have to buy another mattress but then we can easily live on the money I spend just on myself. It would be fantastic if this became a house of artists!

Theo, Gauguin has written that he's coming! He doesn't yet feel fit enough for the long journey, but as soon as he's better he's coming! In the meantime, I've been busy making Gauguin's room as nice as possible. It still needs some furniture and I've also done a couple of new paintings of sunflowers. I'm going to hang them all over the house and in Gauguin's room. All together I've already finished nine! I worked so hard on them that I nearly dropped. I could hardly see, my eyes were so tired. But I still want to do another three. Then soon I will have painted maybe twelve large sunflower paintings. How about that!

Only I've spent too much money again. I wanted to frame them nicely, so I ordered frames. But I couldn't actually pay so much because there's also the rent and the cleaning lady. And of course I have to eat now and then. But I managed it all because I lived the last four days on twenty-three cups of coffee with bread and that was fine.
You may think I'm stupid, but I want to make an impression on Gauguin with these sunflowers. He's already a good painter, that's why I so want to show what I can do.

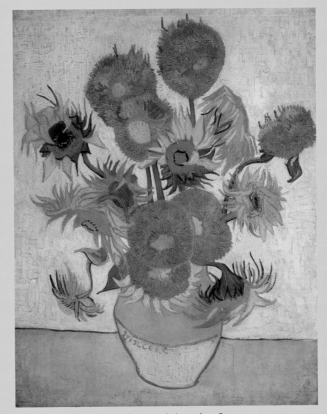

Vincent did many paintings of sunflowers

Living together with Gauguin

Dear Theo, he's here. Gauguin arrived this morning! I really think he was enthusiastic about the house and everything. We took his things to his room and then I showed him the town and the surrounding area. Gauguin told me that he used to sail. He told wonderful stories about all his experiences. Do you know that he's been to the tropics and painted there? He's a very interesting person with a lot of experience. I can learn a lot from him.

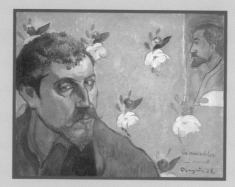
A self-portrait by Paul Gauguin

There's no eating in a restaurant; that's too expensive. He shops for groceries and I cook. At least, I was going to make soup once but according to him I'd mixed the ingredients just like I mix the colours in my paintings. He thought the soup was inedible. You should have seen his face when he tasted it. I roared with laughter. But from today, he cooks. I let him have his own way to keep the peace. Otherwise he may get fed-up with Arles!

Theo, now I still don't know what Gauguin thinks of my sunflowers. He hasn't mentioned them. But perhaps he still will. We went out again today to paint landscapes and it went really well. I painted The Sower. An immense lemon yellow disc of sun in a green sky with pink clouds. The field violet. The sower and tree Prussian blue. Gauguin is working on a landscape, too. But he's a very precise person. All my tubes are mixed up in my paintbox. Although I do know how to find my colours. But his paint tubes, with their lids neatly screwed on, lie like tin soldiers in a row in his box. And now he's trying to tidy me up because he finds the chaos I live in "shocking". And he thinks the way I handle money is terrible. That's why we now have a separate purse for everything; for groceries, for the rent, for tobacco.

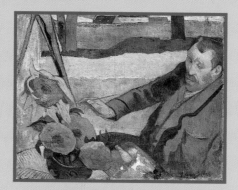
Gauguin painted Vincent painting sunflowers

From the moment he arrived here, Gauguin has said that I'm just making a mess. Especially these works with clashing colours. All that yellow and purple I find so exciting, he doesn't like at all. "Monotonous harmonies which lack a wake-up call," he keeps saying. And he also takes the mickey out of my colour dots. In any case, he doesn't think much of Impressionism. We spend our days working and then working some more. I often work very quickly. I can't help it. The ideas for a painting flood through me. I have no time to think or feel. I'm a painting locomotive. For instance, I painted The Ploughed Field in one go. I smear large daubs, straight from the tube, onto the canvas in one go. I can't change anything, impossible. I seek the intensity of the moment.

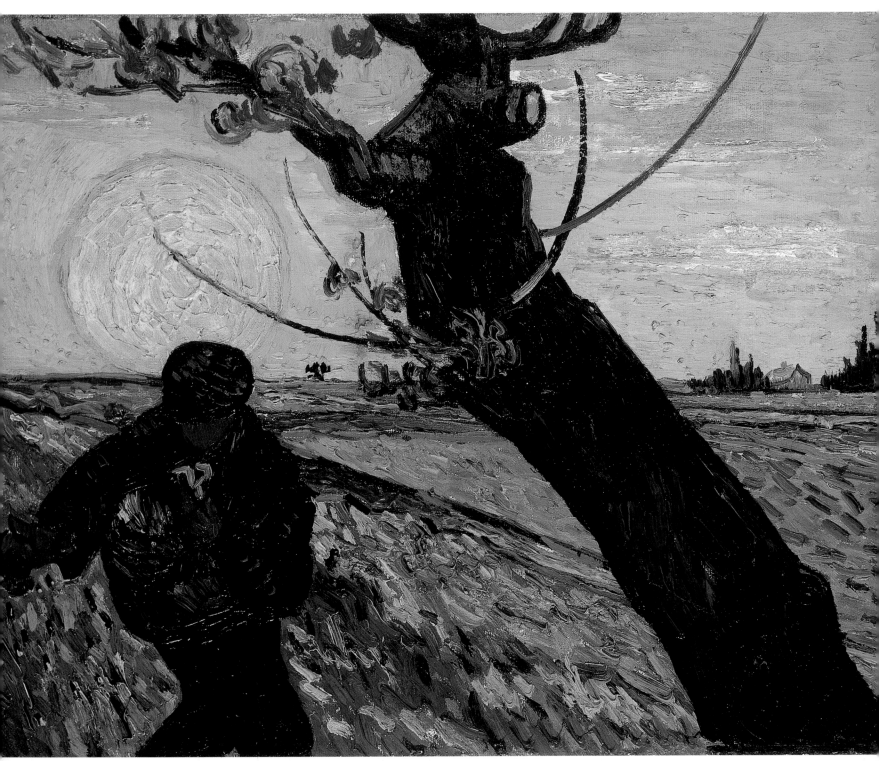

The sower with a huge sun

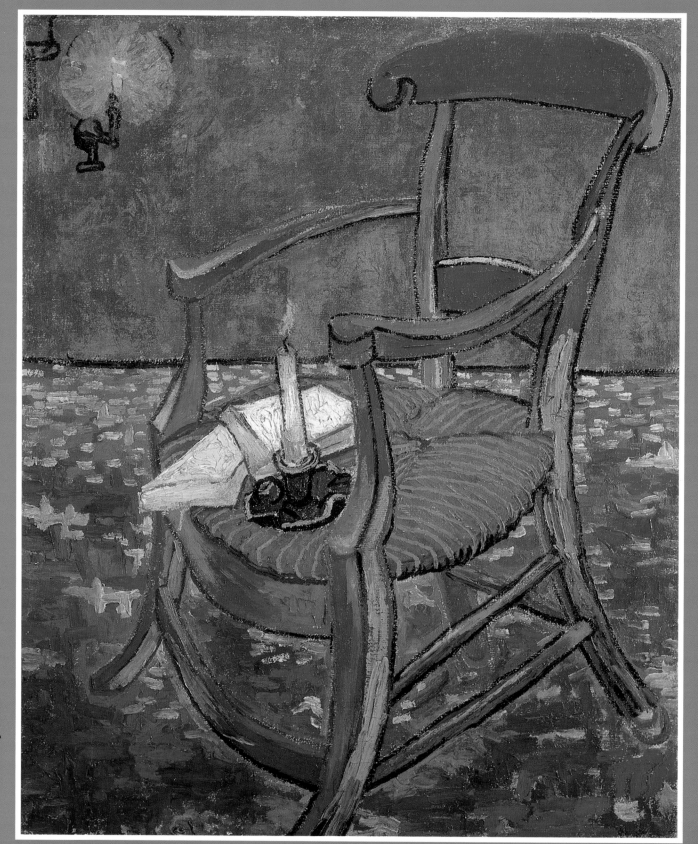

Gauguin's chair

A quarrel

Gauguin says he can't work that way. In fact, we hardly ever agree about painting. In the evenings we just carry on: endless discussions about which painters are good and which are not. He goes on and on about Cézanne, Ingres and Degas until it makes me crazy.

Sometimes I'm afraid he's disappointed in me. That he's had enough of the yellow house and will leave. I've painted his chair to imagine that emptiness. I don't want to think about it and try to let him have his own way as much as possible. But yesterday he started to drone on endlessly again about everything. I wanted him to stop but he kept on. This isn't right, that's not right. And suddenly, I don't know what came over me, but I saw red. I picked up a knife. "And now shut up or..." Of course I didn't mean it but he ran out of the door. And he didn't come back. I went looking for him everywhere, to say I was sorry, but I couldn't find him anywhere. When I finally got home, his room was empty. Everything was gone! He had taken his things and just left! I was desperate. I thought: "Vincent, you've messed it up again! Why can't anyone stand you? Because you're always such a terrible know-all. Because you can never listen. Then you certainly don't need your ears. After all, you never use them." I picked up the knife and sliced off a piece of my ear. Then I ran into the street and screamed: "Gauguin, here's my ear. I will listen to you. But don't go, please come back!"

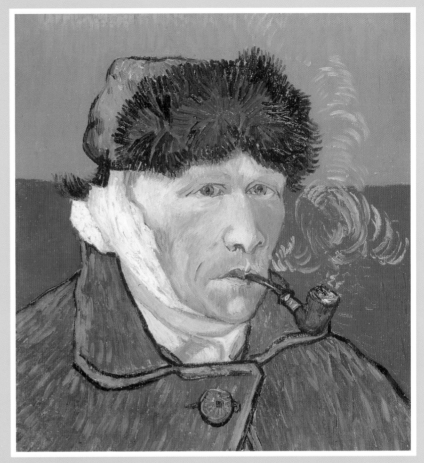

Vincent wore a large bandage for a while after he sliced off a piece of his ear

They found me unconscious in the street. I was bleeding profusely. The police took me to a hospital and someone wrote to Theo. He came immediately. The doctor says I'm in a deep nervous crisis and that I have to stay in the hospital for a while. I want to cry but the tears won't come.

I stayed in hospital for a couple of weeks. Until I felt better and was allowed to go home. I wanted to start work again. But I'm not allowed to get excited or overtired. Because then I could have another nervous attack. I promised the

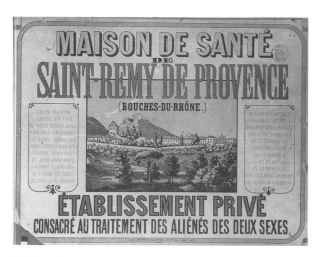

This advertisement says the asylum in Saint-Rémy is a 'house of health'

Some peace

Dear Theo, I think it's a good thing I came here. The people in this asylum are all stark staring mad. You hear screams and cries the whole time, as if you're in a zoo. Then someone else has an attack. It's really frightening but also rather reassuring, because there are people who have the same as me. They hear those strange sounds and voices and echoes in the hallways, too. That's why I'm a bit less afraid of my attacks. I now know that it's part of my illness.
I'm allowed to go outside to paint but I don't feel like it. I don't want to leave here for the time being. I shall probably become like all these other people here who just wait for days, weeks, months, years for the food to arrive.

doctor I would stay calm and went back to my yellow house. But the neighbours acted strangely. They had become afraid of me, because of that knife of course. I tried to explain it to them, but children started throwing stones at my windows. They swore at me and climbed up my house. And no one tried to stop them. In the end I ran after those horrid boys myself. Now they've given a list of signatures to the mayor to say that it's dangerous to let me wander around freely. They say I'm mad and demand that I be locked up. The police came to get me and took me back to the hospital! This upset me so much that I suffered another terrible nervous attack.
I'm afraid. I don't want to go back to my house again. Theo writes that, because he's now married to Jo, perhaps it would be better if I want back to Mother in Holland. But I daren't. I feel as if I could have a new attack at any moment. The doctor said there's a suitable place in Saint-Rémy where I can find peace. Because peace is the only way to get better.

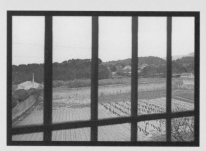

One of Vincent's rooms,
with bars at the window

I've been given a room to myself and another room in which to paint. Through the barred window I can see a cornfield above which the sun rises breathtakingly beautiful every morning. I've started working a bit again. I painted my window. Perhaps I'll paint that cornfield one of these days, when I feel like going outside again. It's such a pity that Gauguin and I didn't keep going. Together we could have made a real artists' house out of our yellow house where even more painters could have worked.

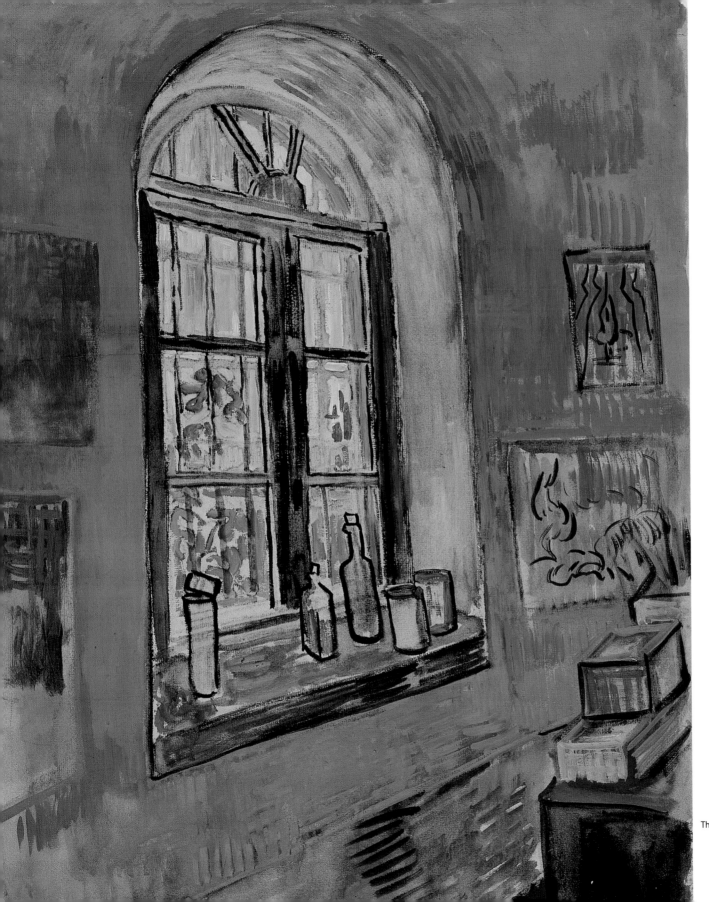

This is how Vincent drawed his room

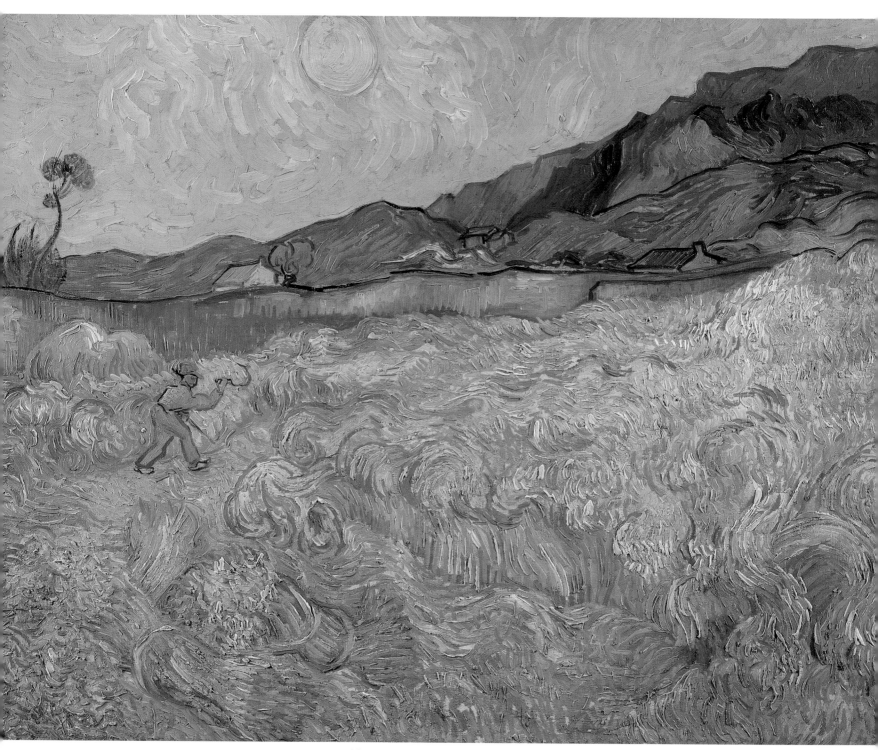

Vincent painted the countryside around the asylum

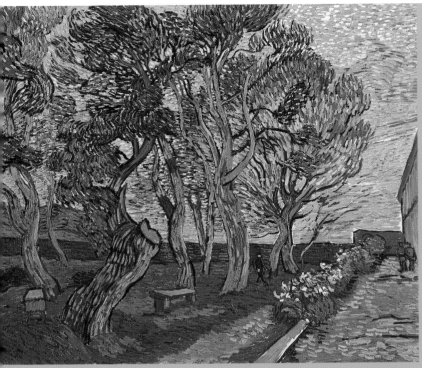
The asylum garden at Saint-Rémy

wanted to have a word with my neighbours. But just seeing those people brought on another terrible attack.

It's over, thank goodness. It lasted three weeks this time. I was unable to do anything all this time because of this damned illness. They had tied me to a bed in a small room because I smashed everything to pieces. Now I feel so dreadfully empty. I can't stand it here any more. I can't go outside because this dreary winter is so endless. I'm bored to death. I can't keep doing self-portraits or the view from my window. I wish I could leave, go back to Paris, back to Theo and my friends.

I'm going to be an uncle! Theo wrote that Jo is pregnant. He'll be a father and if it's a boy, he'll name him Vincent!

I've had another attack! I'd gone outside to paint. Because I felt so terribly lonely. And then I thought about Sien, but that's just what I shouldn't have done because that's when it started. Somehow I got back inside. This attack lasted five weeks! They tell me I even tried to eat my paint and to drink petroleum. But I don't remember much about it. Thank goodness the crisis has gone and I feel normal again. I've been working hard because I hope the attacks won't return if I paint. I do at least one painting each day. I did a self-portrait and then another one. After that I painted various places in the garden. There are plenty of lovely spots in the asylum garden, like the stone steps at the side. Or those ivy-covered trees at the back where it's so wonderfully cool and fresh.

Because I still had some paintings in the yellow house, I went to Arles with someone from the asylum. I also

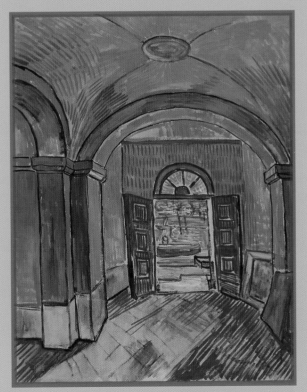
The hall of Saint Pauls hospital

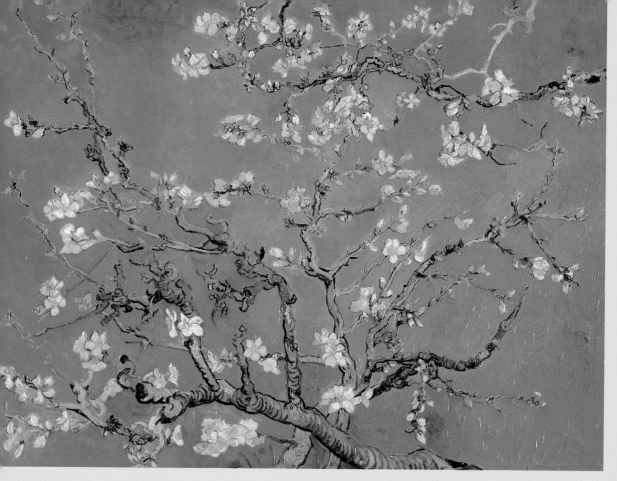

The flowering almond branches which Vincent painted for Theo and Jo

but they took no responsibility if it went wrong. Well, then I could just stay here until kingdom come, I'll never be completely better. My patience is gone, I can't cope any more. I need a change, even if it makes things worse. Now I know I'll finally be leaving here, I suddenly feel like painting again. These days I get up early each morning and then I work without stop until late at night. Big bunches of flowers, irises and roses. Plus six landscapes and the "starry night".

I must try and get back a taste for life. Just eat more again, no matter how disgusting these beans are every day. And I'm going out for a while again to mess about with my paintings. It's the first time in weeks that I've been outside. I want to paint large branches with white almond blossom for Theo and Jo, for above their bed.

Theo writes that if I really can't stand it here, I can stay with him in Paris for a while. I can't say how pleased I am with this letter. I immediately discussed it with the management here. They said vague things as if they thought it was okay

This is it. I packed my cases this morning. After that I popped outside for the last time. Everything was so fresh and in full bloom after the rain. There's so much here still to paint!

Someone from the asylum took me to the train. At first they wanted to take me all the way to Paris, but I didn't want that. I'm not a dangerous animal. If I suffer an attack during the journey, I'm sure someone will know what to do on the platform. Anyway, I've just had an attack and then it always takes a while before I get another one. I want to take advantage of this peaceful period to leave here.

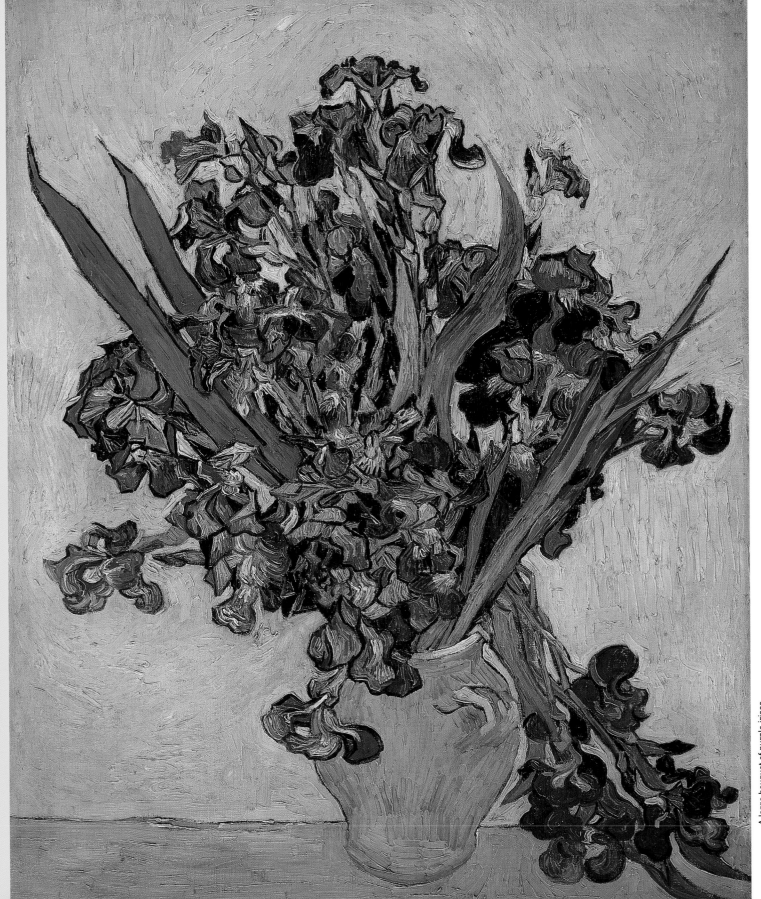

A large bouquet of purple irises

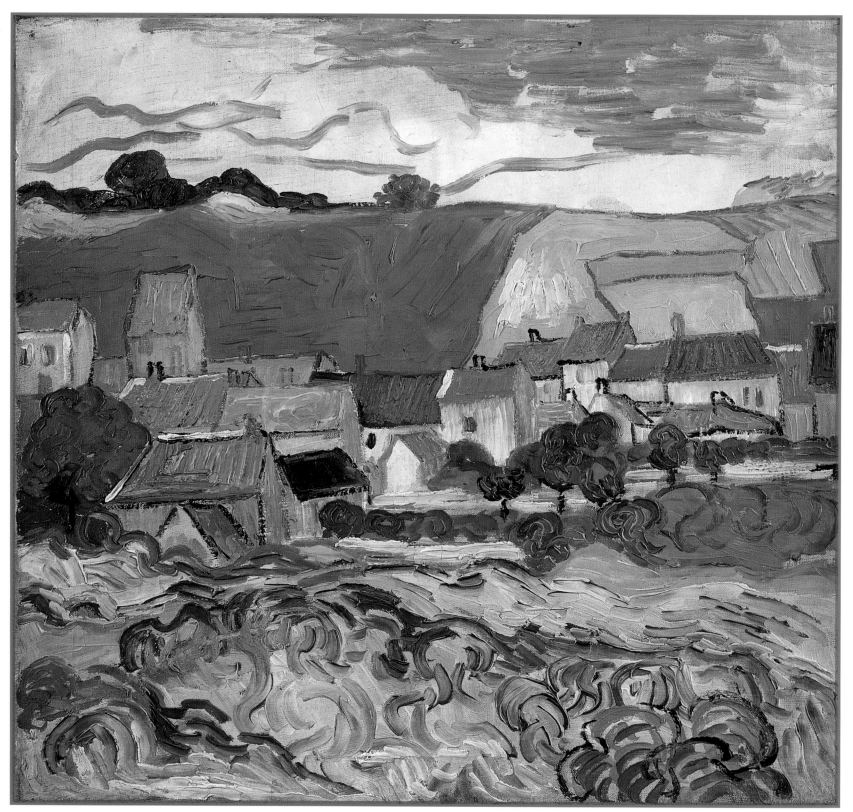

The village of Auvers-sur-Oise near Paris

Just back to Paris...

You see how well it went! Absolutely nothing happened on the way. Theo collected me from the train in Paris and then we went to his house. Jo even thought I looked healthy. Theo took me to the bedroom where the cot stood and I finally saw little Vincent. He lay so sweetly sleeping with two clenched fists and a very serious face. We had tears in our eyes. I said to Jo that she must spoil him rotten.

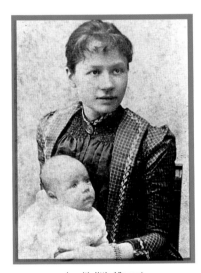

Jo with little Vincent

I've been with them three days now. We never talk about the asylum. Sometimes I help with the shopping, and the rest of the time I look at my paintings which hang all over his walls. The flowering orchards hang in the bedroom, The Potato Eaters is in the dining room above the mantlepiece. The large landscape of Arles with the irises hangs in the sitting room. And the rest lie everywhere: under the beds, under the couch, in the cupboards, in the guest room. Huge piles of canvases without frames. I'm terribly shocked now I see how badly Theo is looking after our collection of paintings. And I told him so, too!

All my artist friends come to visit me. Toulouse-Lautrec even stayed for dinner. But I can tell it's too much for me. The noise and so on. Even more people want to come, but

The inn where Vincent rented a room

I can't take it. I must be off, otherwise I can tell I'll have another crisis.

... and then to Auvers

Theo put me on the train to Auvers. It's only thirty kilometres from Paris. A friend of ours, Camille Pissarro, said I should go there because it's so beautiful and rural. He lived and worked there for years himself. Apparently there's even a good doctor who can help me if I have another attack. He's called Dr. Gachet.

I found a small room in an inn and then I went to find Dr. Gachet. He's a nice fellow, I think. He lives on a hill in a lovely house full of paintings. I've arranged to go and paint on Tuesday morning and then stay for dinner.

My dear brother, you're gallery can go to hell. No one ever buys my paintings. You finally have to take Jo and little Vincent on holiday and come here. It's so beautiful here. I've done an etching of Dr. Gachet. I'm not saying I can do this, but when I do a portrait I want it to be more than a good likeness. I try to express the person's character. In my portrait Dr. Gachet has the face of an overheated brick. Because this man is just as disappointed in his profession as village doctor as I am in painting. By the way, I told him I'd be glad to swap jobs with him.

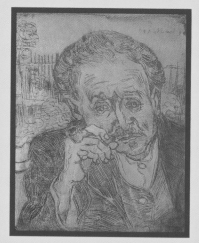
Vincent made this etching of Dr Gachet

I usually try to be fairly cheerful but I feel my life has been attacked at the roots. Every new attack makes me weaker. I don't think I'll ever fully recover. But I work every day, and although the brush nearly falls out of my hand, I have painted another three large canvases. Outstretched wheat fields with a flock of black crows hovering above. I'm not ashamed to express my worst sadness and loneliness in these paintings.

Dear Theo, thanks for the letter and the fifty francs. I worry more and more about the future. I understand that, now you have a family, it will be more difficult for you to send money every month. It's a pity that you've hardly ever been able to sell my paintings. Still I just want to say this, and I mean it from the bottom of my heart: you're different from all those art dealers who just want to sell work by famous artists in order to make a quick and easy profit. I say this because, when I still lived with you in Paris, we often quarrelled about this. Remember how I blamed you for doing too little for modern art? Well anyway, I risk my life for my work and I've become half mad from it, too.

But you, and I say this with all the seriousness my mental state is capable of, you, my dear brother, have had a very important share in the production of my paintings through the way you've always cared for me and through your financial support.

I would love to write about lots of things, but I have the feeling there's no point any more. It's too much for me: the worry, the loneliness, the fear of a new attack.

Vincent

The last letter (with bloodstains) that Vincent wrote to Theo. was found after he died.

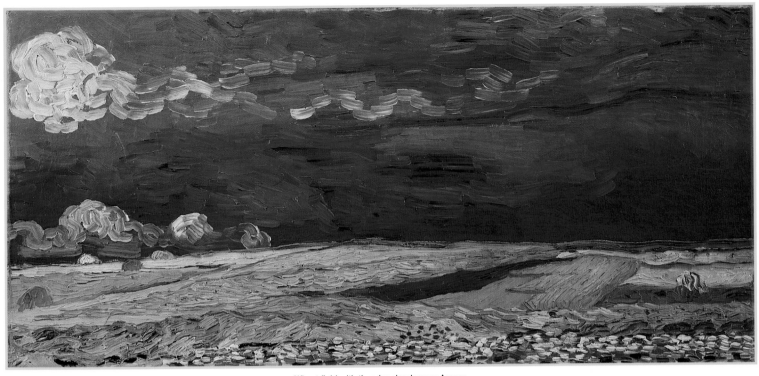

Wheat field with thunder clouds near Auvers

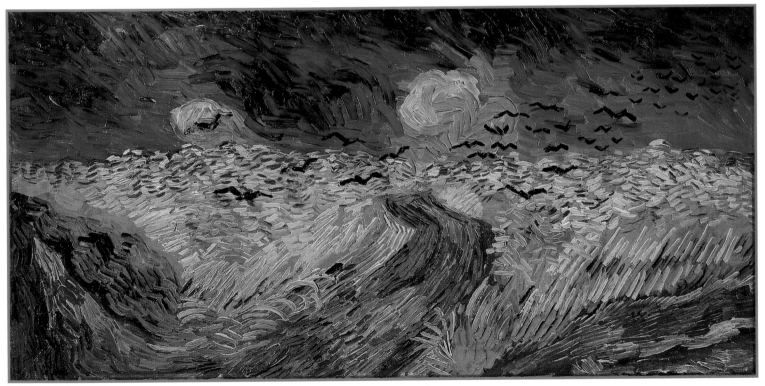

Wheat field with crows near Auvers

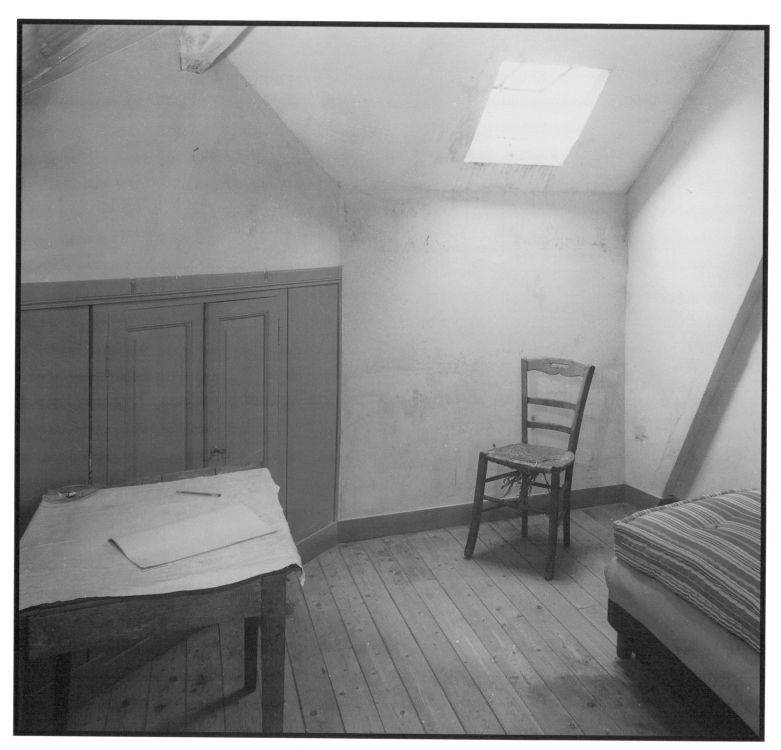

The room in Auvers where Vincent died in 1890

The end

On Sunday 27 July 1890 at nine in the evening, Vincent stumbled, bent double and with a hand to his stomach, back to the hotel. He had shot himself in his stomach with a pistol in the wheat field. He was badly injured but wouldn't see a doctor. Theo came as soon as he heard about the accident. He kept watch over Vincent during those last hours. They lay next to each other, with their heads on the same pillow. Just as they did when they were children in Zundert, when they made plans for the future...

Theo was broken hearted with grief. His own health was already delicate and he never got over the shock. He died six months after his brother.

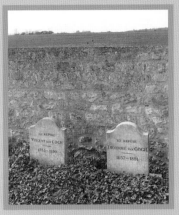

The headstones of Vincent and Theo van Gogh

Vincent van Gogh

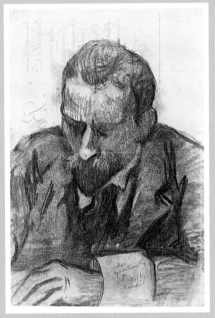

Theo van Gogh

Epilogue

From around 1880 to 1890 Vincent and Theo were brothers in art. Vincent painted and Theo sold and collected art, often with Vincent's advice. After the death of both brothers, Theo's wife Jo looked after their collection of paintings and prints. She also sorted the hundreds of letters which Vincent and Theo had written to each other. The letters in this book are based on these real letters. When Jo died, her son Vincent looked after this collection of paintings, prints and letters. He set up the Van Gogh Museum in Amsterdam in 1973. There you will find the largest collection of paintings by Vincent van Gogh. You will also see many of the paintings which Theo bought or acquired otherwise. It has been over a century since the brothers died and still every day thousands of people enjoy the paintings of that struggling lonely artist, who ranks among the most famous painters of modern history.

Photocredits

All the illustrationmaterial is loaned from the Van Gogh Museum, Amsterdam (Vincent van Gogh Foundation), unless otherwise is mentioned.
All the paintings and drawings are made by Vincent van Gogh, unless otherwise is mentioned.

2)
Theo van Gogh, Vincents father
photo / Tralbaut

Anna Cornelia van Gogh-Carbentus, Vincents mother
photo / Tralbaut

Birthplace of Vincent van Gogh in Zundert
photo / Tralbaut

3)
Drawing of a spider

4)
Youth-photo of Van Gogh
photo / Tralbaut

5)
Interior school
photo / Nationaal School-museum, Rotterdam

Boarding school in Zevenbergen
photo / Tralbaut

Studies of animal and human heads
black chalk on paper
Zundert, 1862

6)
Interior of Gallery Goupil
photo / Tralbaut

7)
Exterior of Gallery Goupil
photo / Tralbaut

8)
Theo van Gogh
photo / Tralbaut

9)
Man with a sack of wood
black chalk, pencil on paper
Etten, 1881

Digger
pencil, brush in black ink on paper
Den Haag, 1882

10)
Anton Mauve
Self-portrait
oil on canvas
Gemeentemuseum, Den Haag

Woman sewing, with a girl
mixed techniques on paper
1883

11)
Kee Vos-Stricker and her son
photo / Tralbaut

12)
The vicarage at Nuenen
oil on canvas
Nuenen, 1885

13)
Congregaion leaving the Reformed church at Nuenen
oil on canvas
Nuenen, 1884

14)
The Jewish bride
oil on canvas
ca. 1665
Rijksmuseum, Amsterdam

Head of a woman
black chalk on paper
Nuenen, 1884-1885

Head of a young man with a pipe
pencil on paper
Nuenen, 1884-1885

Lap with hands
black chalk on paper
Nuenen, 1884-1885

15)
Weaver
pencil, aquarel on papier
Nuenen, 1884

16)
A pair of shoes
oil on canvas
Paris, 1886

17)
The potato eaters
oil on canvas
Nuenen, 1885

Three hands, two holding forks
black chalk on paper
Nuenen, 1885

Letter of Vincent van Gogh to his brother Theo
01.03.1886

Plate with cutlery and a kettle
black chalk on paper
Nuenen, 1885

18)
Vase with gladioli and autumn asters
oil on canvas
Paris, 1886

19)
Henri de Toulouse-Lautrec
Poudre de riz
oil on canvas
late 1887

View of Paris
oil on canvas
Paris, 1886

20)
The flowering plum tree (after Hiroshige)
oil on canvas
Paris, 1887

21)
View of Paris from Theo's apartment in the Rue Lepic
oil on canvas
Paris, 1887

22)
Claude Monet
Bulbfield and mills at Rijnsburg
oil on canvas
1886
Instituut Collectie Nederland

23)
Self-portrait with felt hat
oil on canvas
Paris, 1887/1888

24)
Head of an old Arlésienne
oil on canvas
Arles, 1888

25)
View of a butcher's shop
canvas on board
Arles, 1888

26)
Portrait of Joseph Roulin
oil on canvas
Arles, 1888

27)
Sprig of flowering almond in a glass
oil on canvas
Arles, 1888

Portrait of Camille Roulin
oil on canvas
Arles, 1888

28)
Sunflowers
oil on canvas
Arles, 1889

The yellow house ('The street')
oil on canvas
Arles, 1888

29)
The bedroom
oil on canvas
Arles, 1888

30)
The harvest
oil on canvas
Arles, 1888

31)
Café terras at night, Place du Forum
oil on canvas
Arles, 1888
Collection Kröller-Müller Museum, Otterlo

32)
Paul Gaugain
Portrait of Van Gogh, painting sunflowers
oil on canvas
Arles, 1888

Paul Gauguin
Self-portrait with portrait of Bernard, 'Les Misérables'
oil on canvas
1888

33)
The sower
oil on canvas
Arles, 1888

34)
Gaugain's chair
oil on canvas
Arles, 1888

35)
Self-portrait with bandaged ear
oil on canvas
Arles, 1888
private collection

36)
Advertisment for the Saint-Paul-de Mausole asylume
photo / Tralbaut

View with bars from Vincents cellar at the asylum
photo / Tralbaut

37)
Window of Vincent's studio in Saint Paul's Hospital
black chalk, gouache on paper
Saint-Rémy, 1889

38)
Wheatfield with a reaper
oil on canvas
Saint-Rémy, 1889

39)
The garden of Saint Paul's Hospital ('The fall of the leaves')
oil on canvas
Saint-Rémy, 1889

The hal of the Saint Paul asylume
black chalk, gouache
Saint-Rémy, 1889

40)
Almond blossom
oil on canvas
Saint-Rémy, 1890

41)
Irises
oil on canvas
Saint-Rémy, 1890

42)
View of Auvers
oil on canvas
Auvers, 1890

43)
Jo van Gogh-Bonger with her son Vincent Willem van Gogh
photo / Tralbaut

Hostelry Ravoux in 1890
photo / Tralbaut

44)
Portrait of dokter Gachet
etching
Auvers-sur-Oise, 1890

Concept for a letter of Vincent to Theo van Gogh
24 july 1890
Auvers-sur-Oise

Signature on Sunflowers
1889

45)
Wheatfield under thunderclouds
canvas
Auvers, 1890

Wheatfield with crows
oil on canvas
Auvers, 1890

46)
The room were Vincent died
photo / Tralbaut

47)
John Peter Russel
Portrait of Vincent van Gogh
canvas
Paris, 1886

Meyer Isaac de Haan
Portrait of Theo van Gogh
black chalk on paper
Paris, early 1889

The gravery of Vincent and Theo in Auvers-sur-Oise
photo / Tralbaut

Colophon

ISBN 90 400 9354 7
NUGI 213, 921

Publication:
Waanders Publishers, Zwolle
in cooperation with
Kunsthal Rotterdam and
Van Gogh Museum Amsterdam

KUNST
HAL
ROTTERDAM

VAN GOGH
MUSEUM

Author:
Frank Groothof

Concept and support:
Caroline Breunesse
(Van Gogh Museum)

Design:
Stang Gubbels & Anneke van der Stelt, Rotterdam

Editor-in-chief and idea:
Wim Pijbes (Kunsthal Rotterdam)

Translation:
Sue Baker

Printing:
Waanders Printers, Zwolle

© 1999
Waanders Publishers b.v., Zwolle

2nd edition 2001